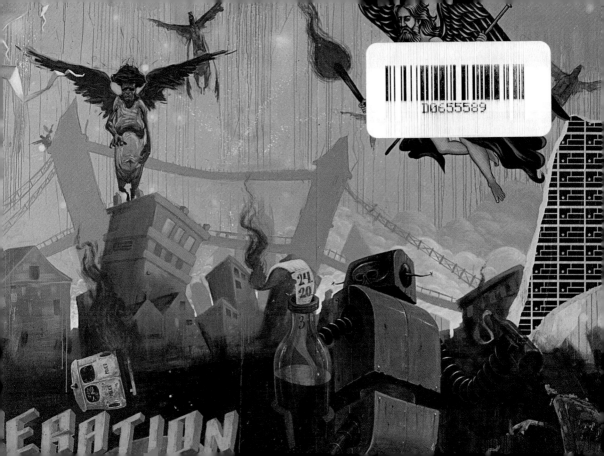

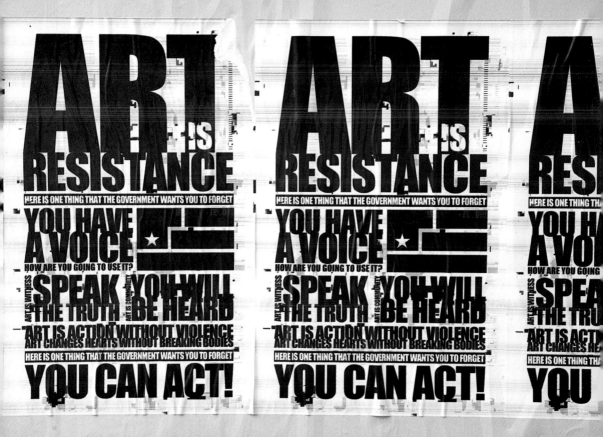

LONDON STREET ART 2

Alex MacNaughton

Prestel

Munich • Berlin • London • New York

LONDON STREET ART 2

After the enormous success of our first book of *London Street Art*
lots of people asked us where to find the amazing works
Alex MacNaughton had found. So this time we thought we'd show
you where he went to find the photos for *London Street Art 2*.

Just go to Old Street Station (Northern line) and take exit 4 to the
east side of City Road South. Then follow Alex's route on the page
opposite. We can't guarantee that everything will still be there,
but keep your eyes peeled and you're sure to find some treasures.

And if you feel like venturing further afield, go north to Muswell Hill
for the chewing gum pavement art Alex found; to Hampstead Heath
to find the tree-trunk art; or over to Soho and the South Bank for
the little space invader mosaics.

Happy hunting!

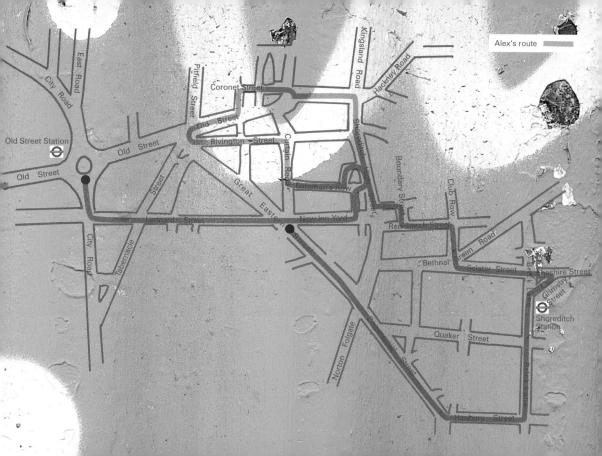

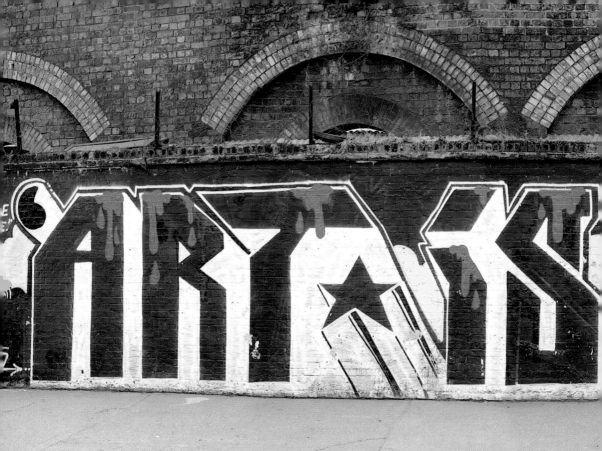

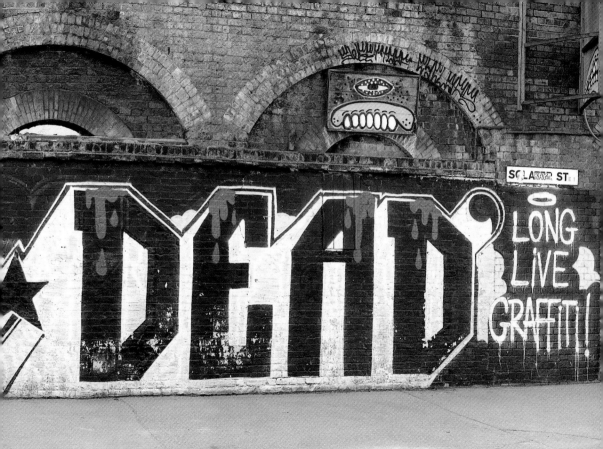

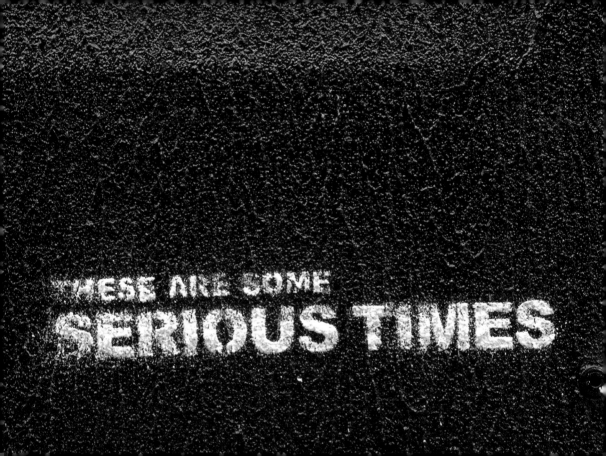

THESE ARE SOME
SERIOUS TIMES

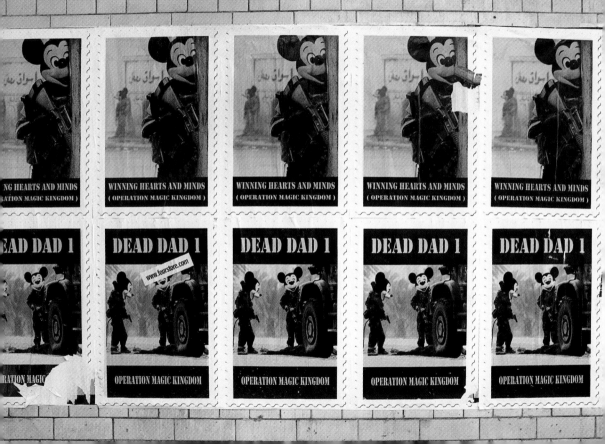

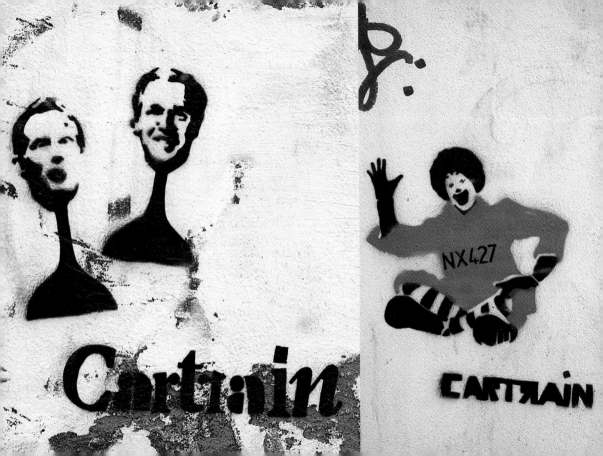

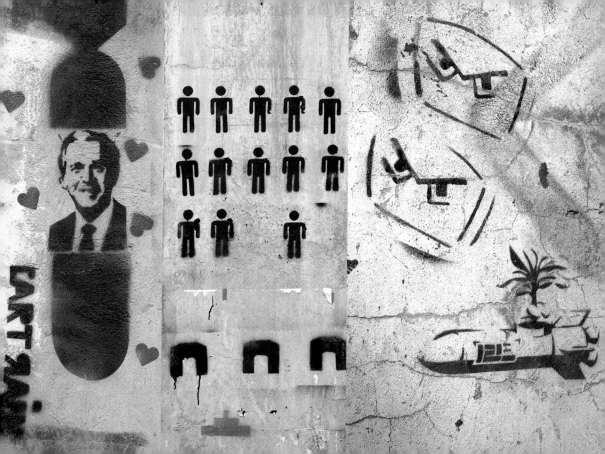

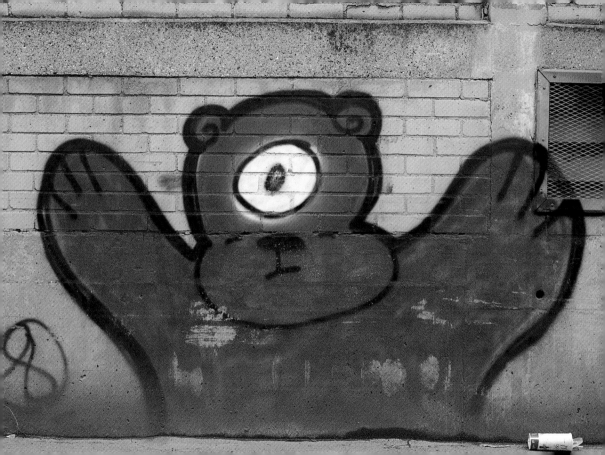

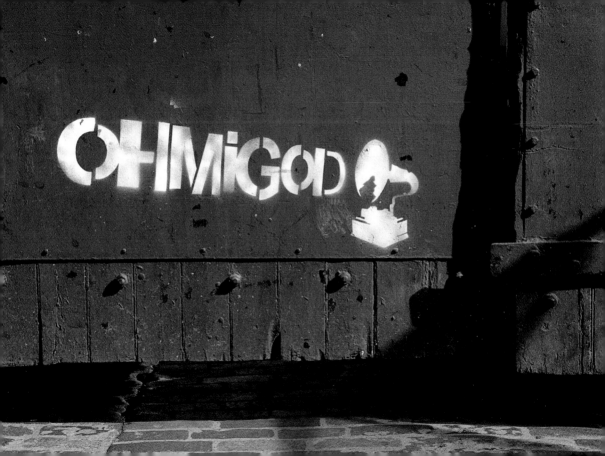

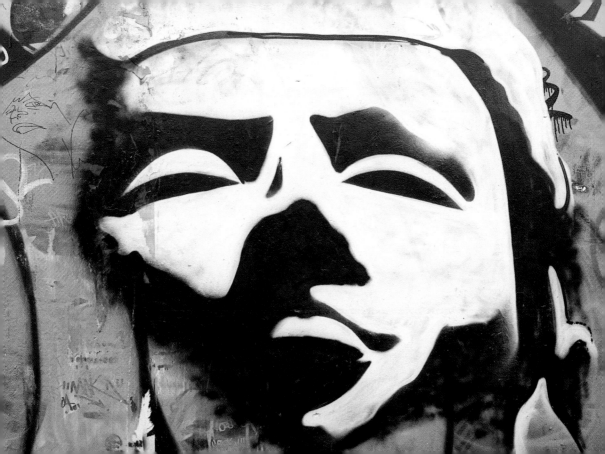

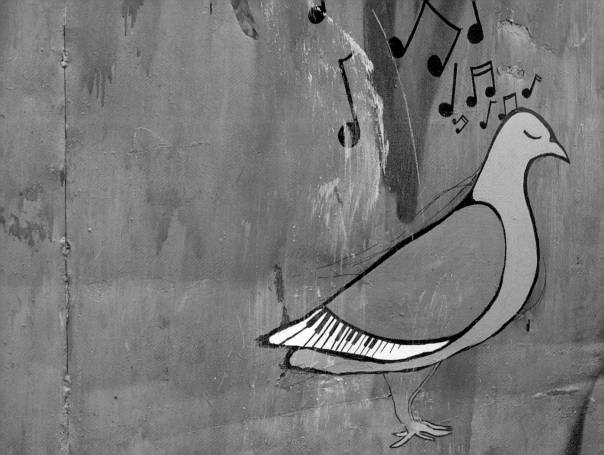

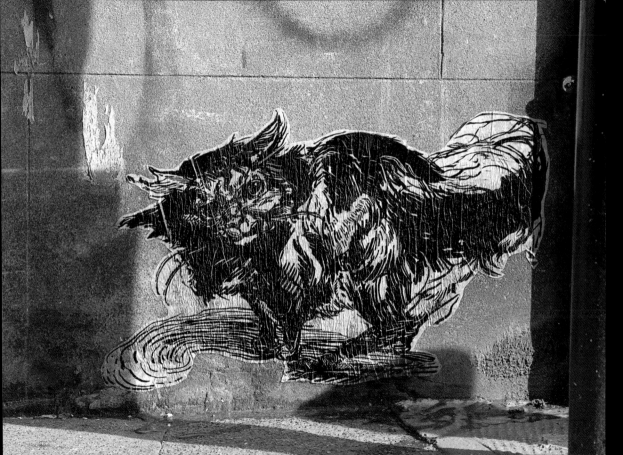

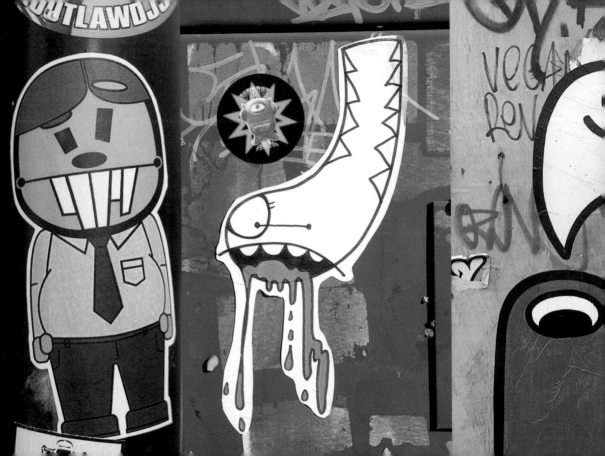

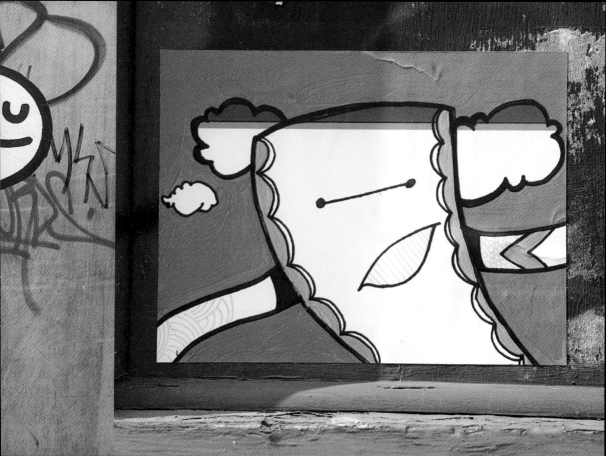

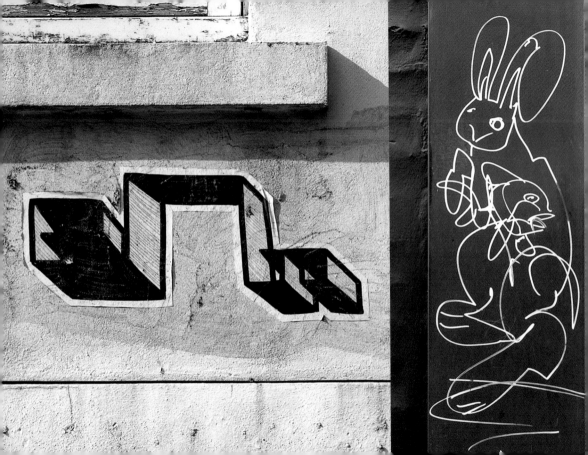

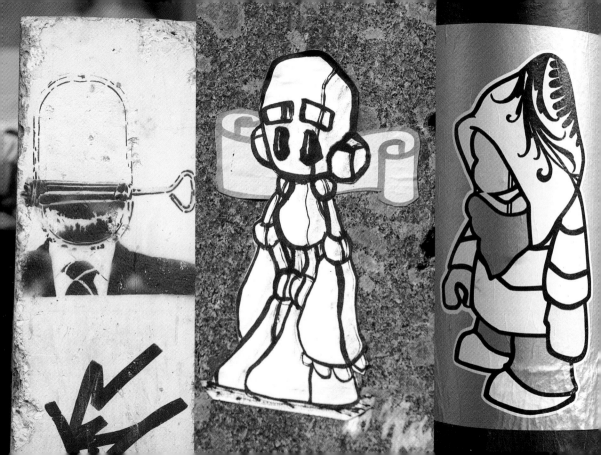

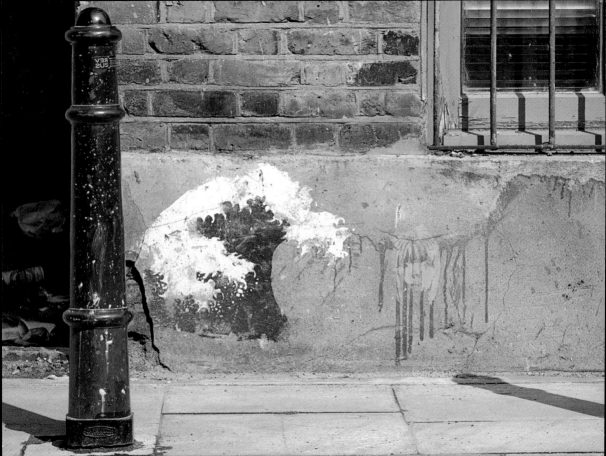

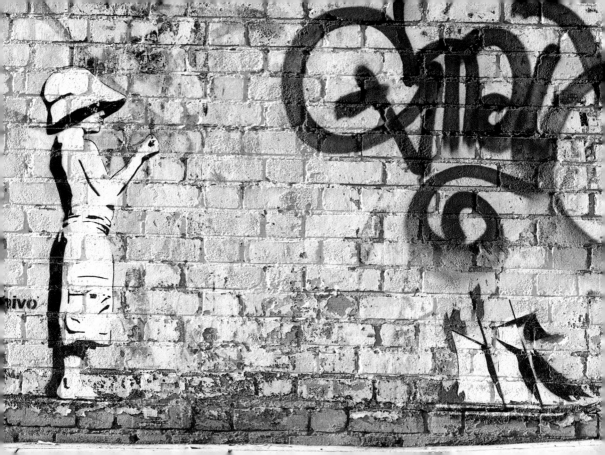

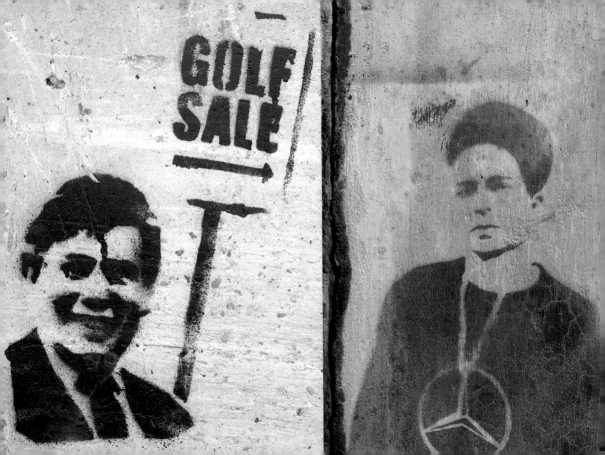

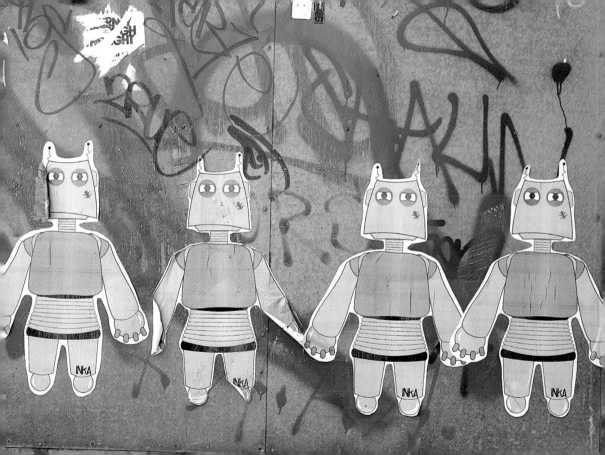

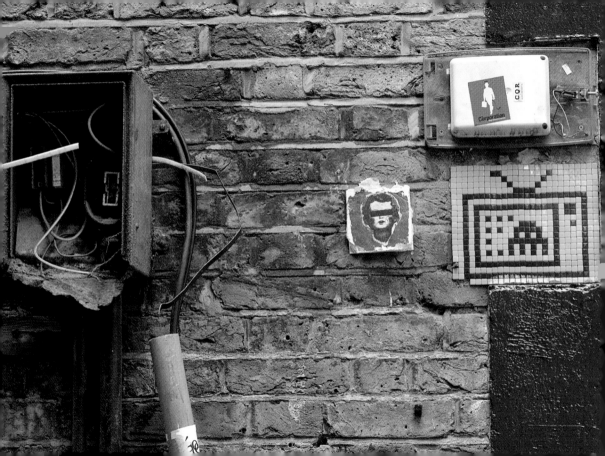

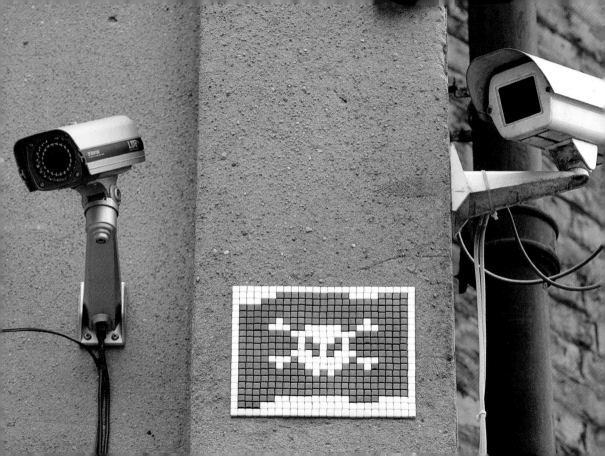

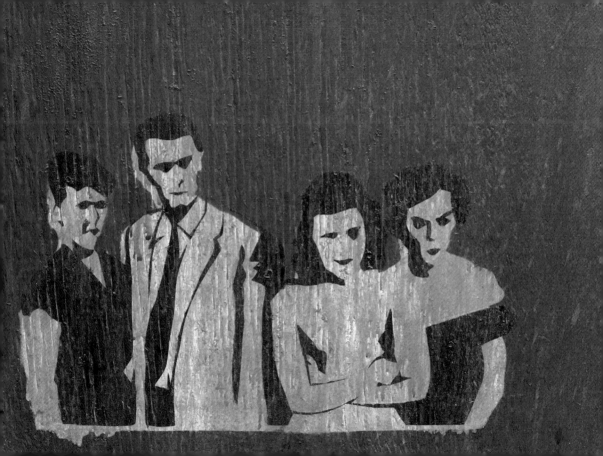

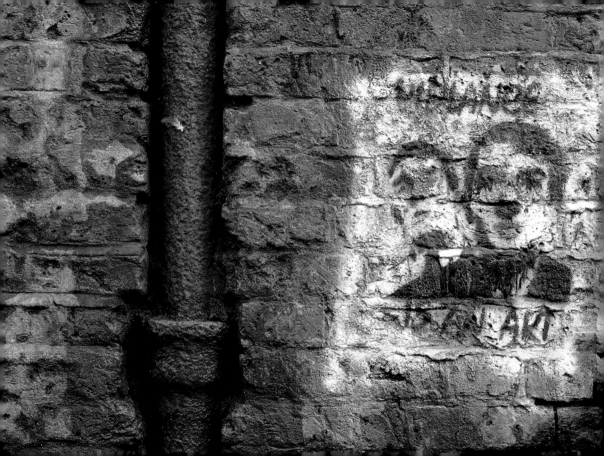

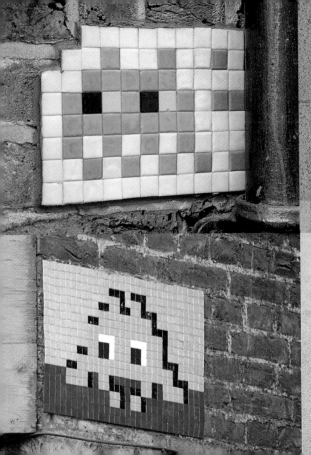

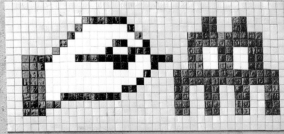

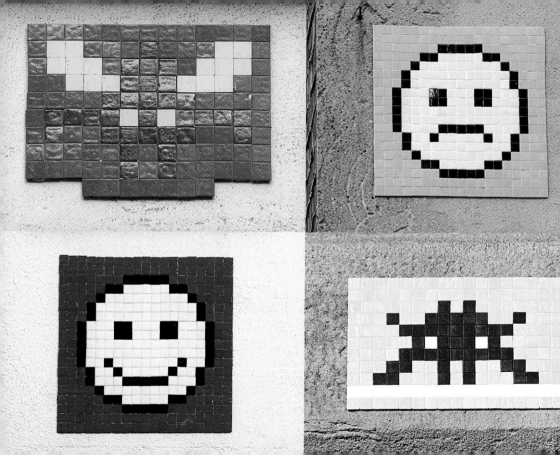

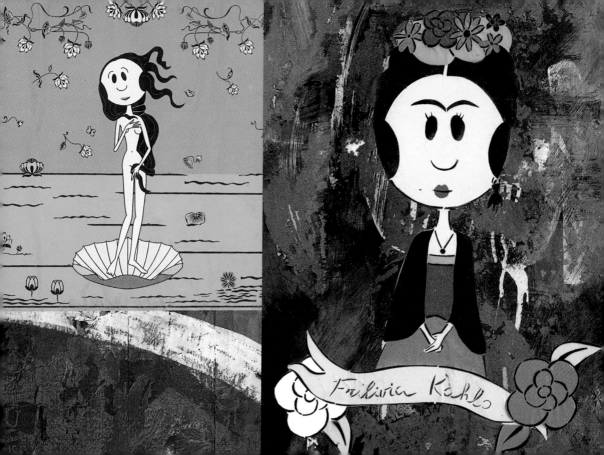

Frida Kahlo

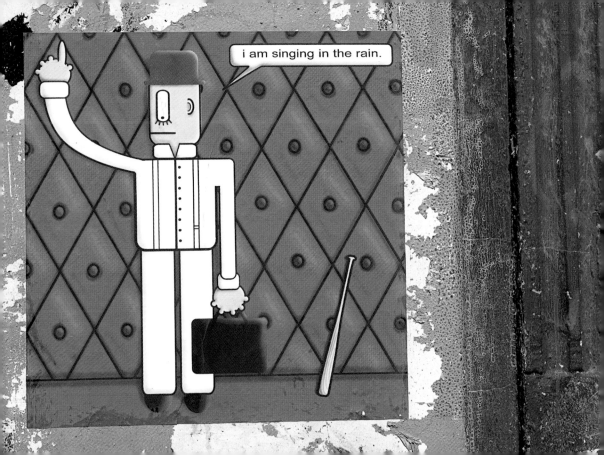

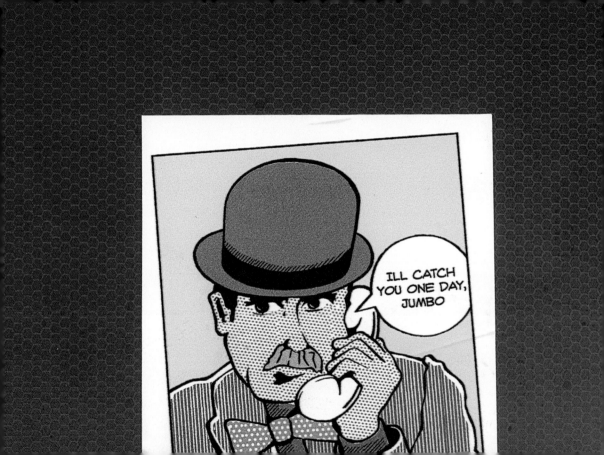

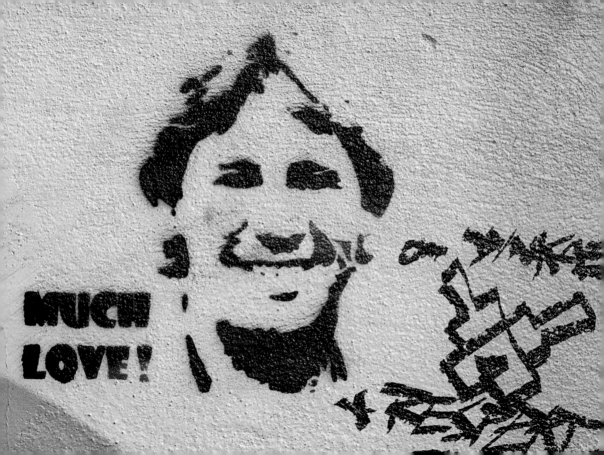

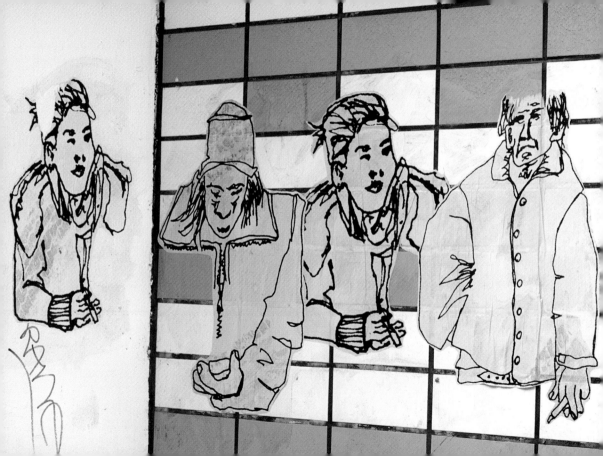

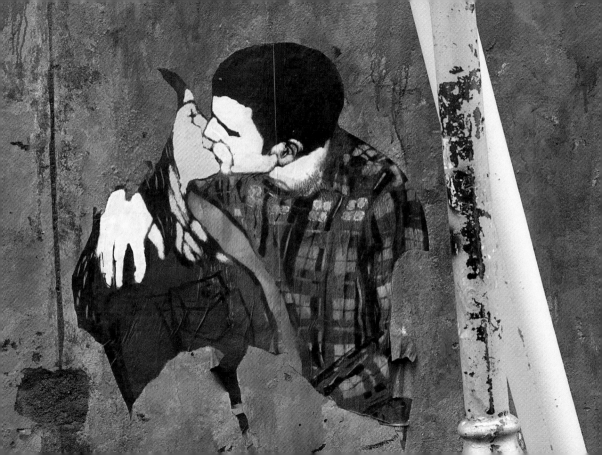

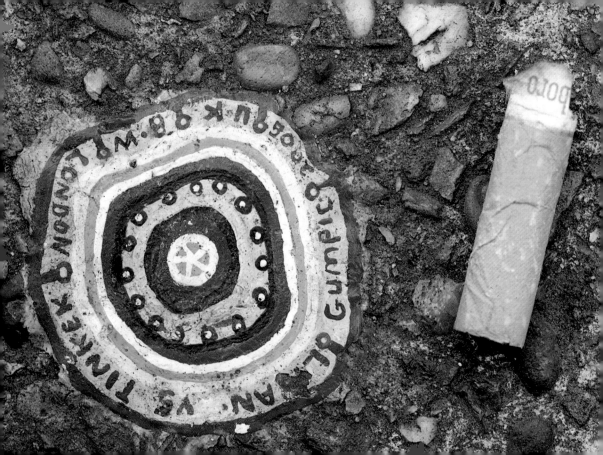

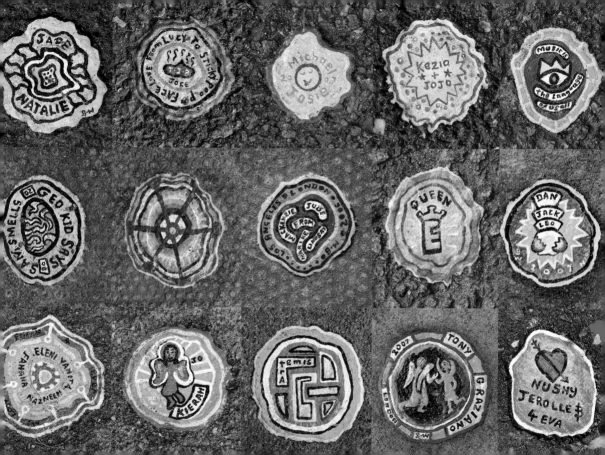

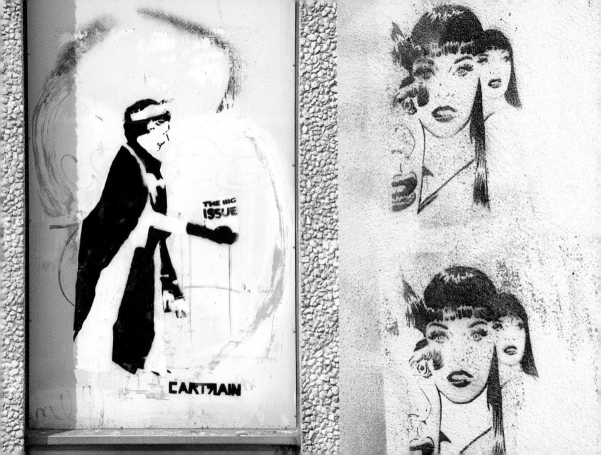

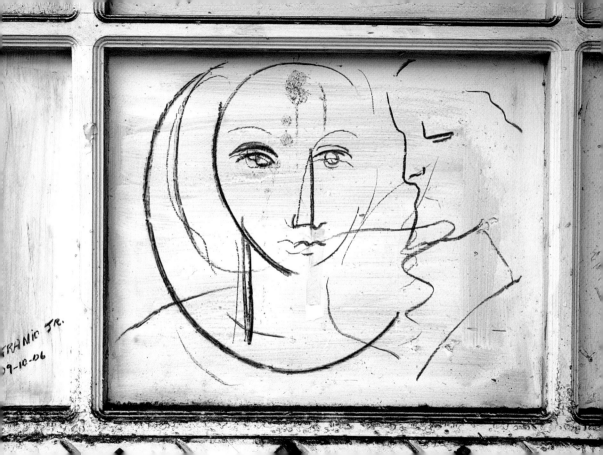

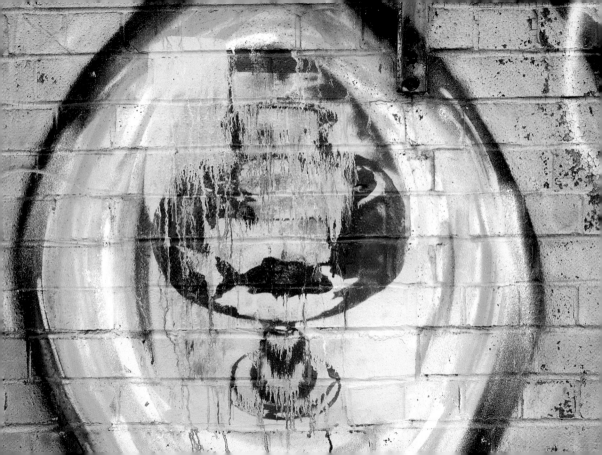

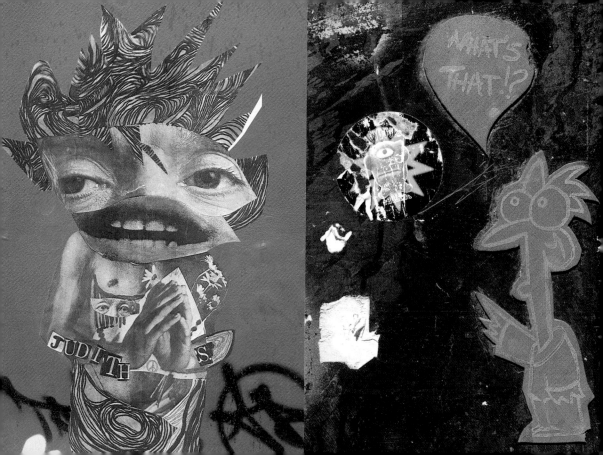

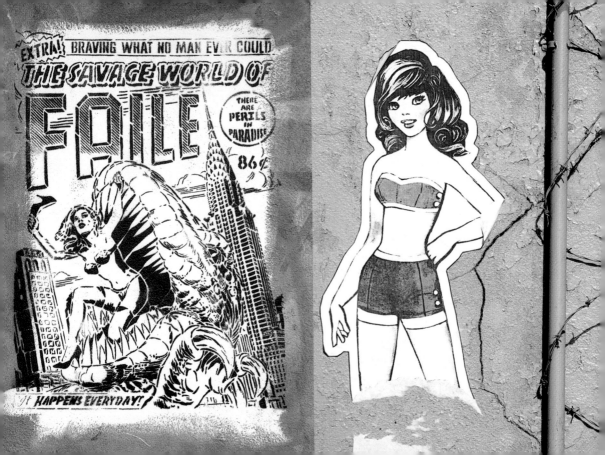

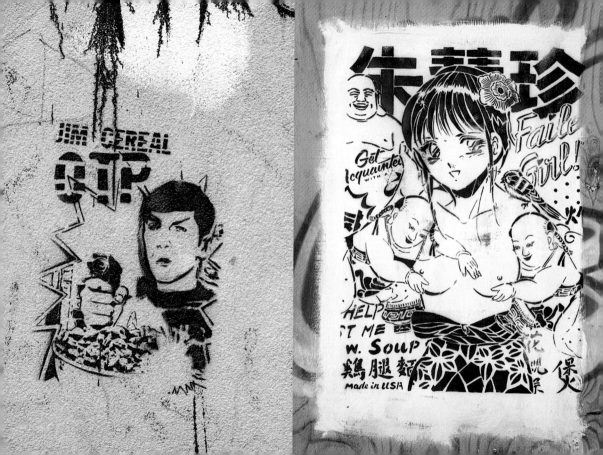

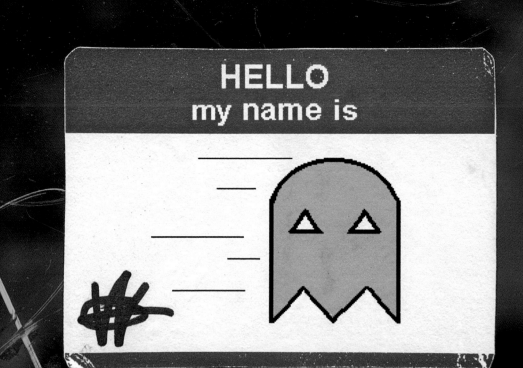

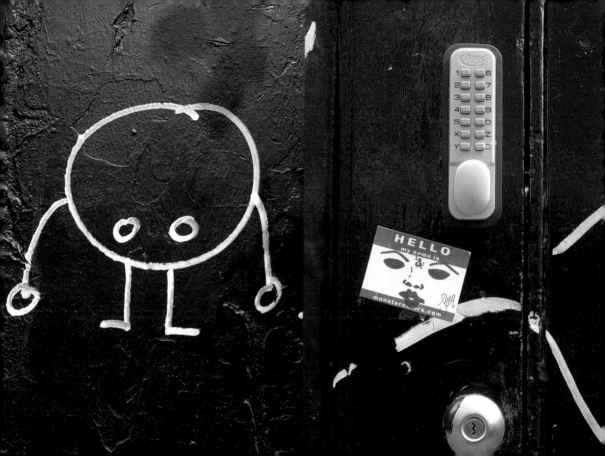

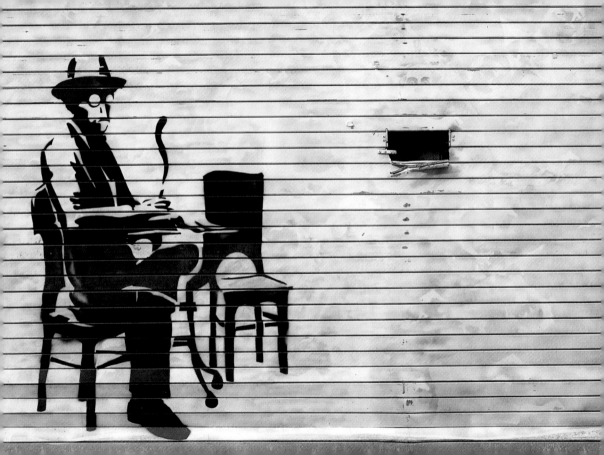

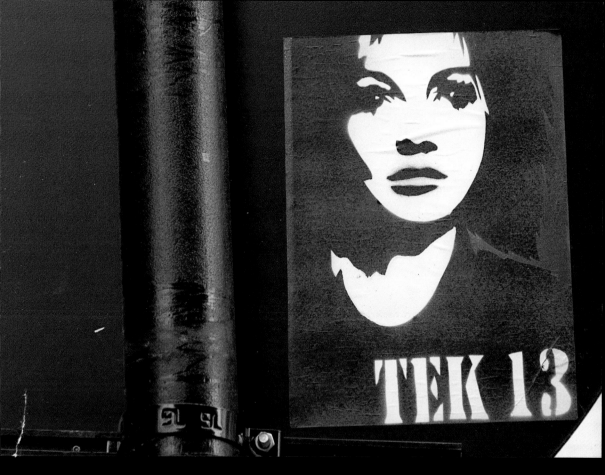

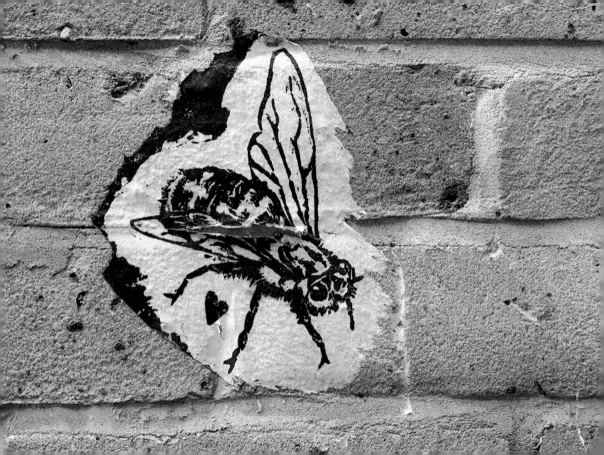

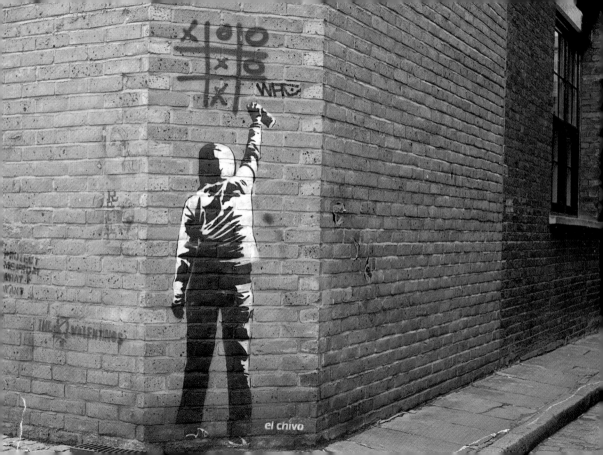

el chivo

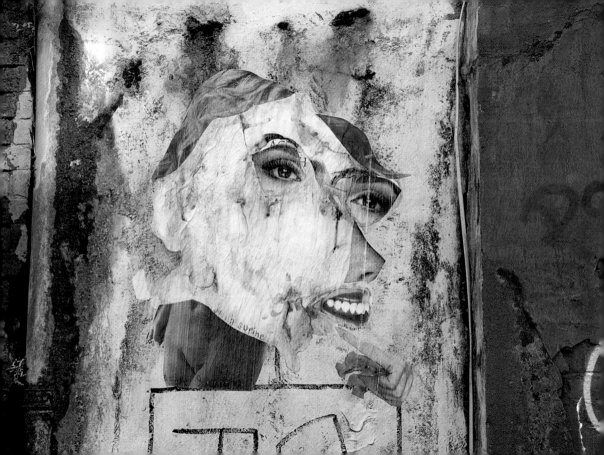

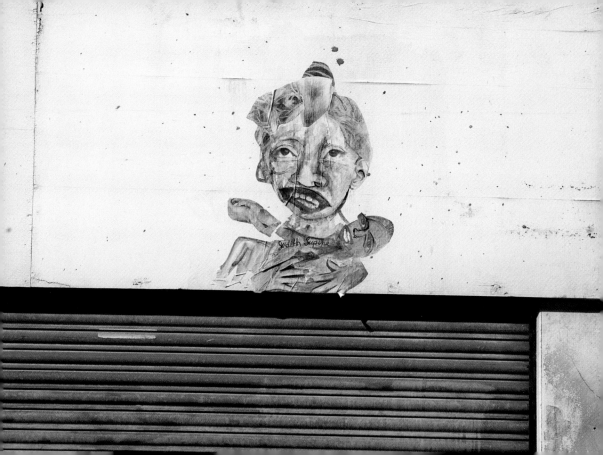

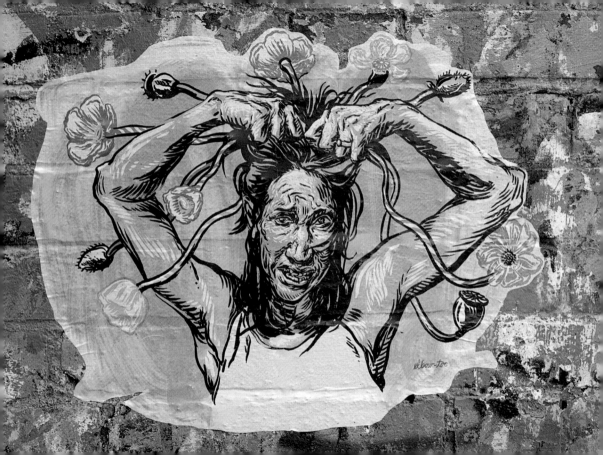

el bon-toe

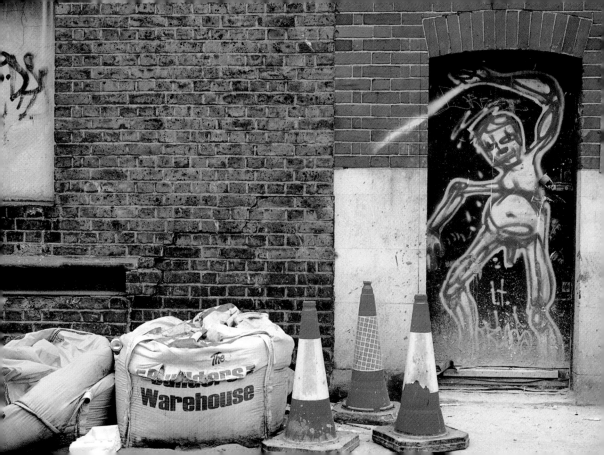

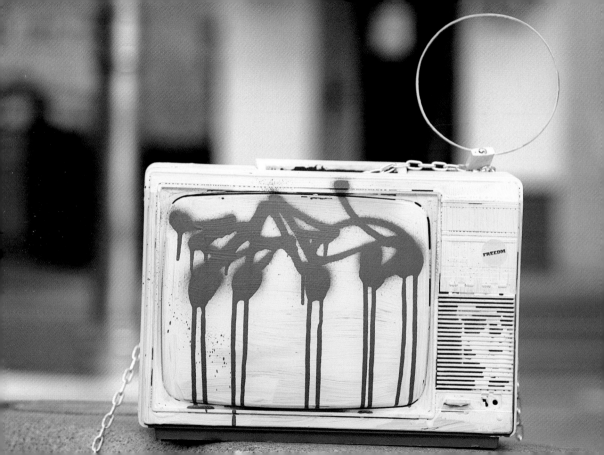

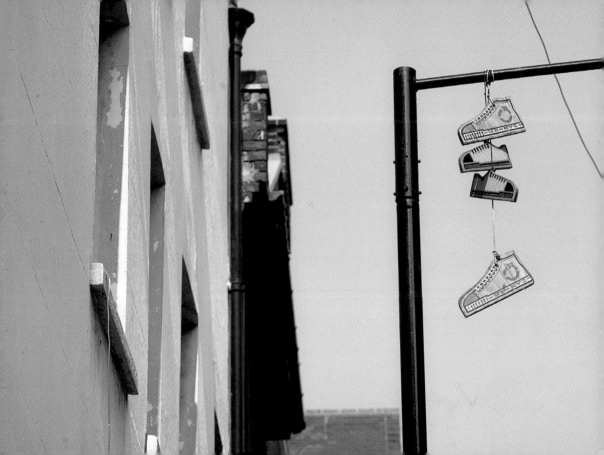

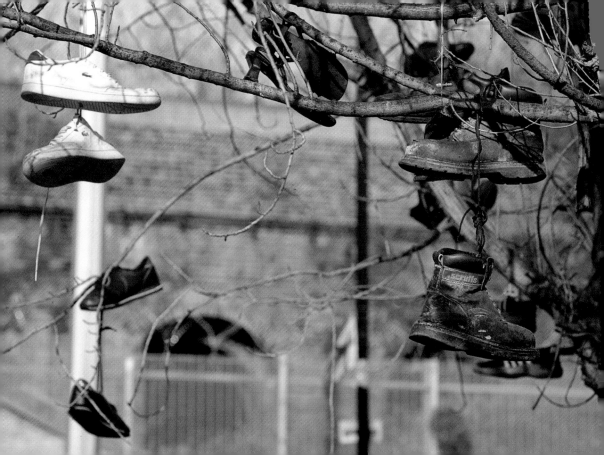

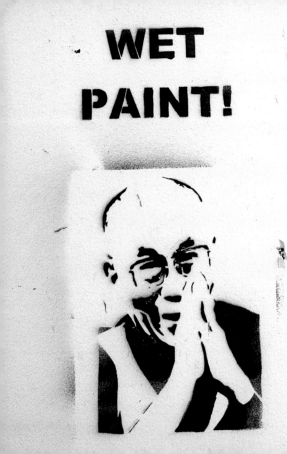

WET
PAINT!

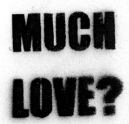

MUCH
LOVE?

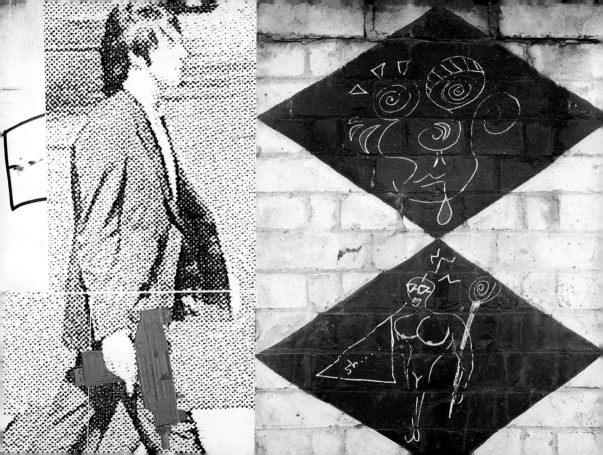

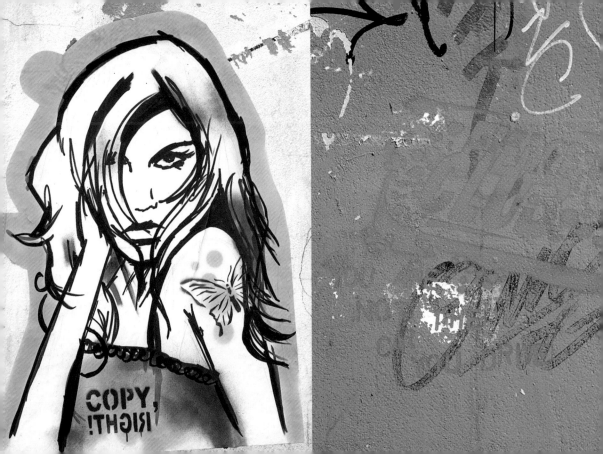

COPY,
!THƏIЯ

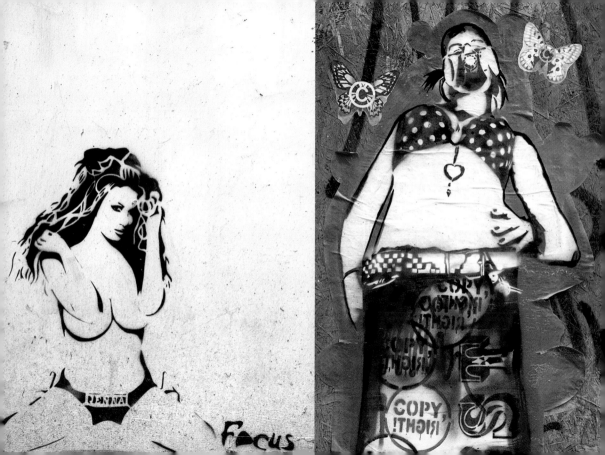

Focus

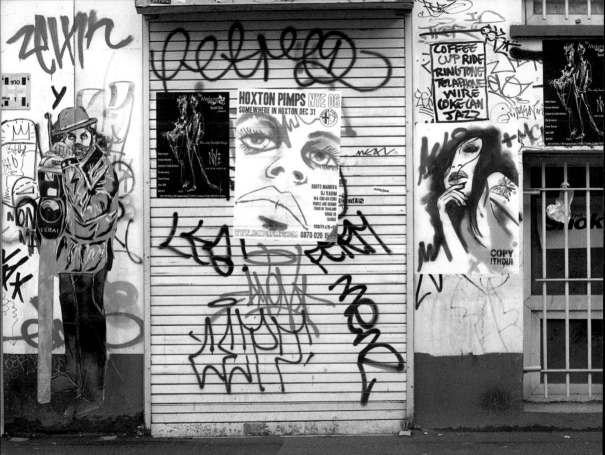

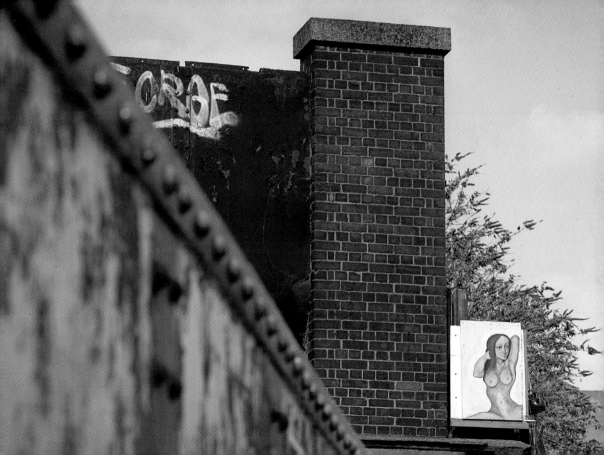

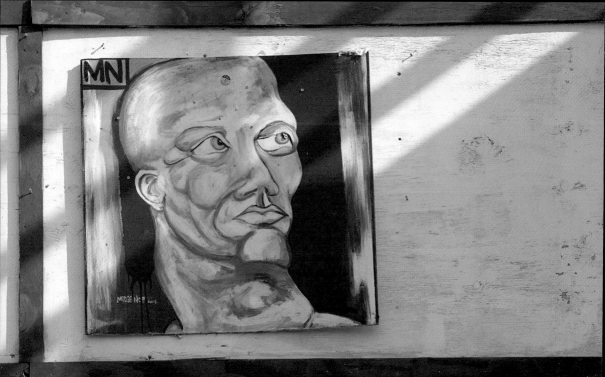

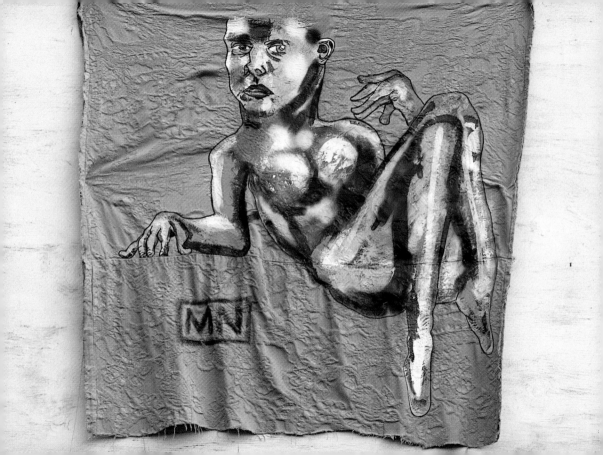

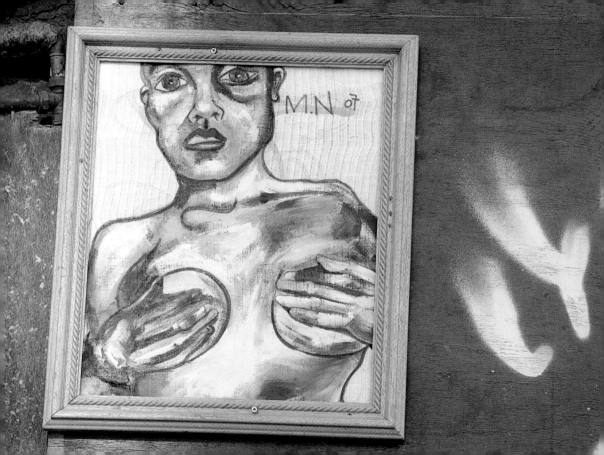

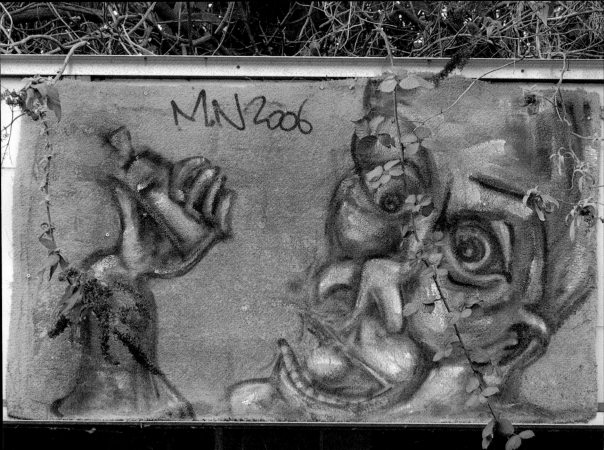

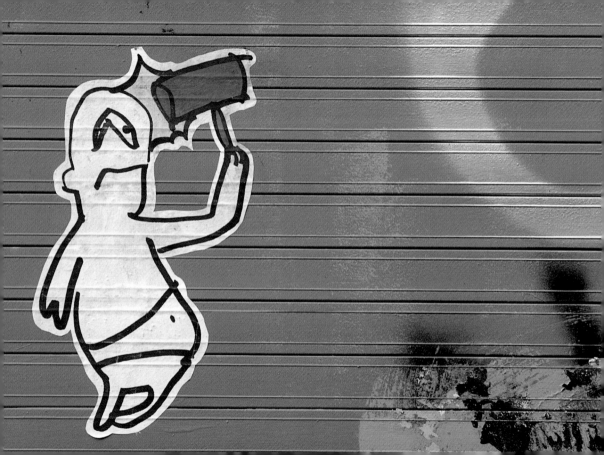

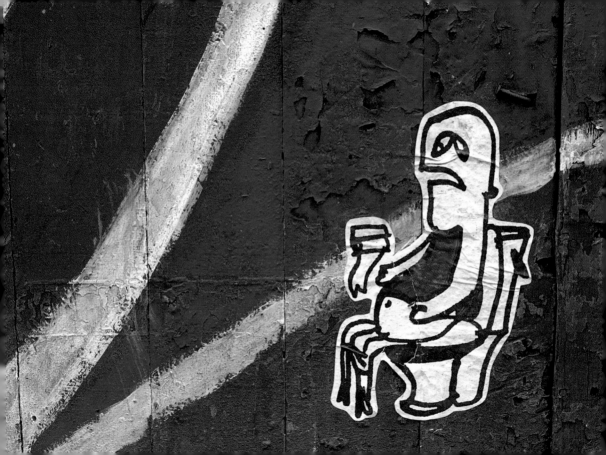

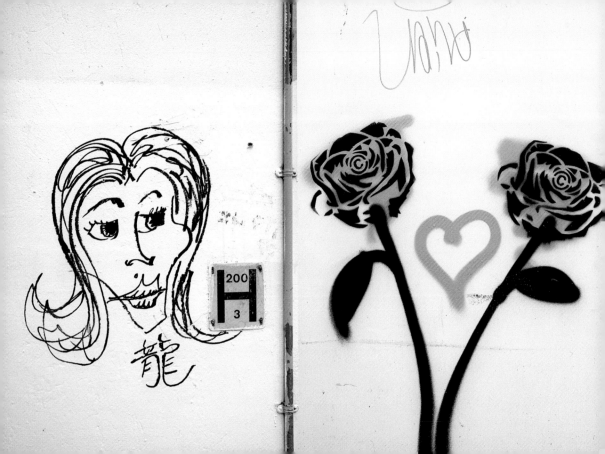

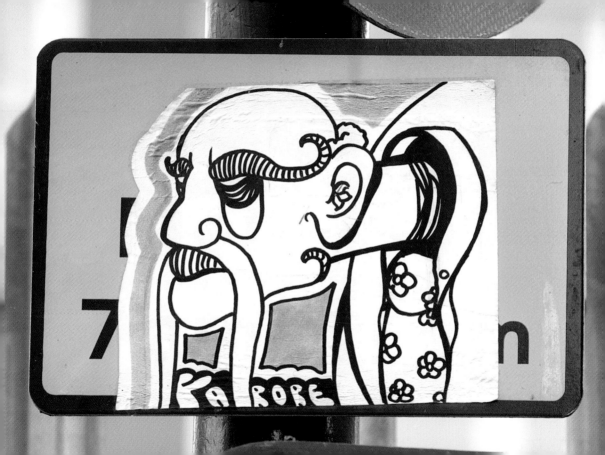

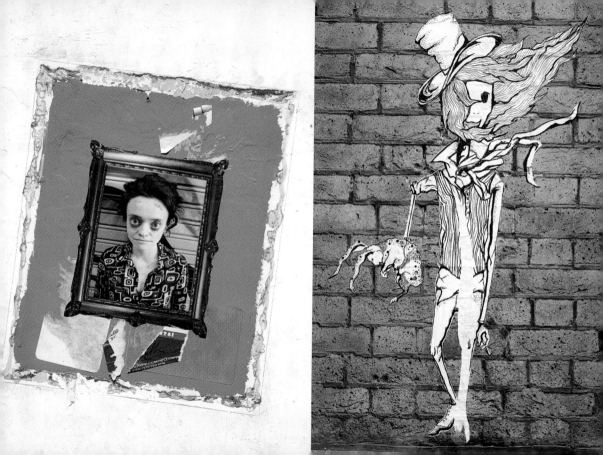

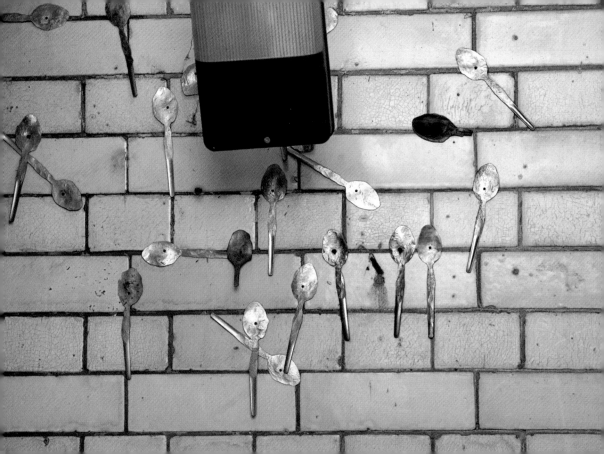

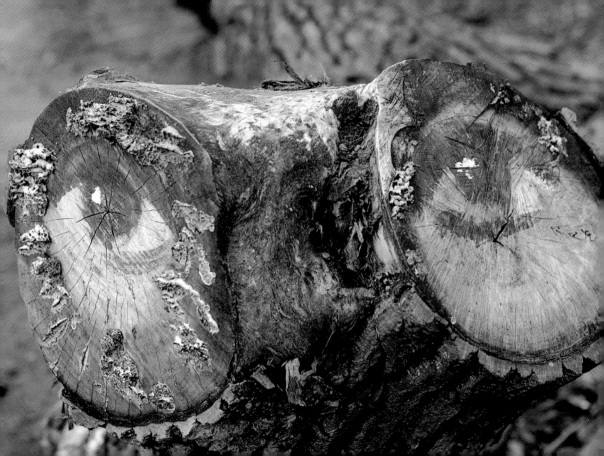

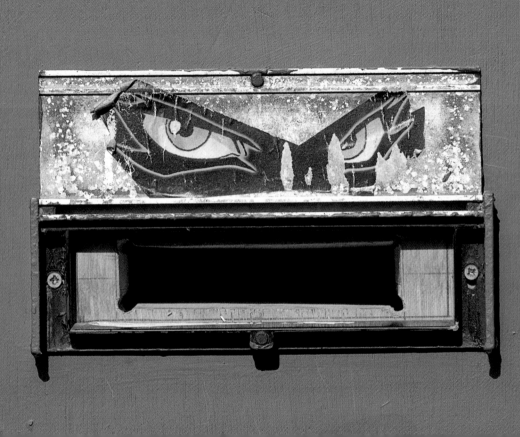

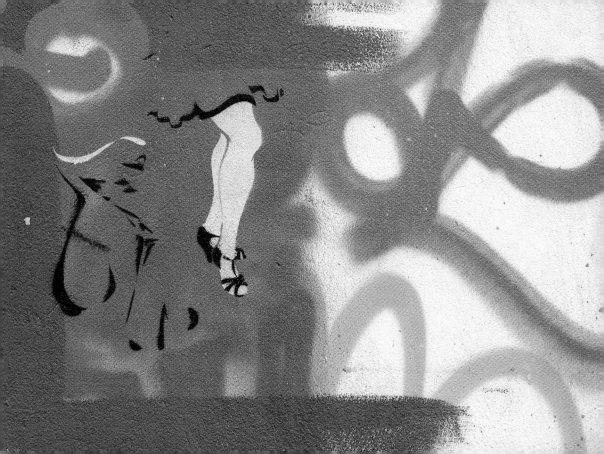

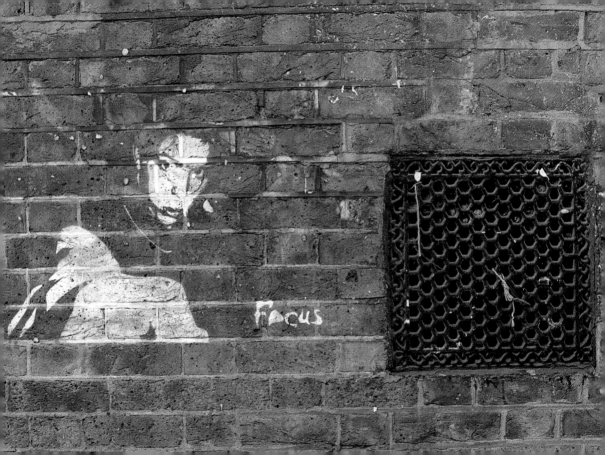

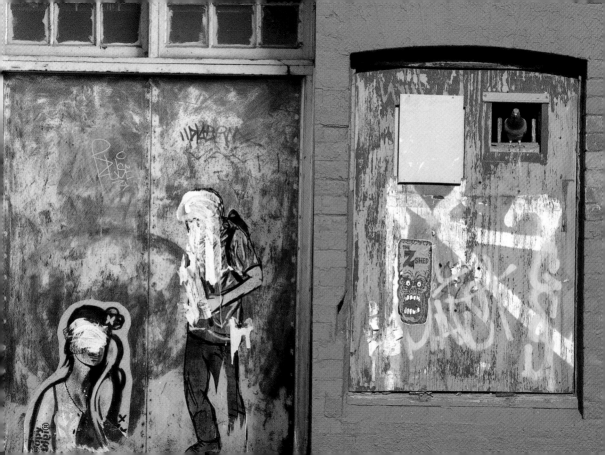

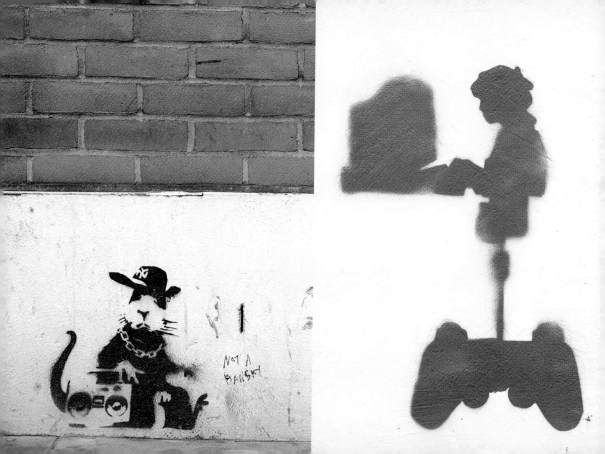

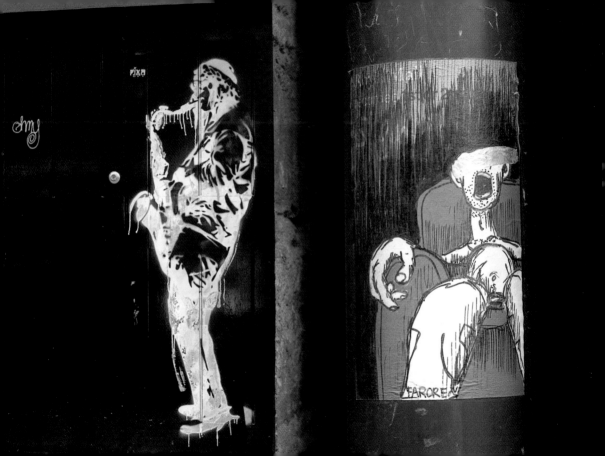

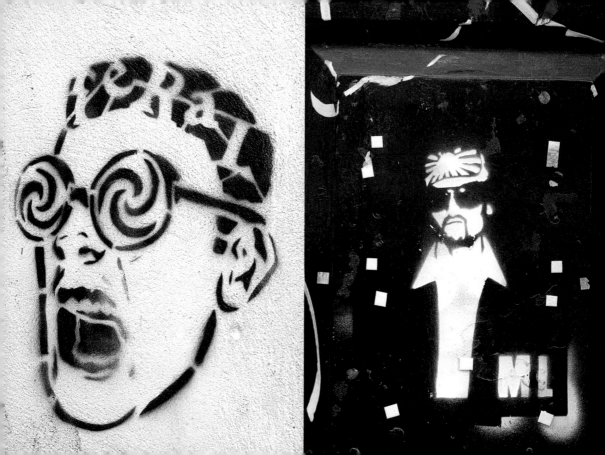

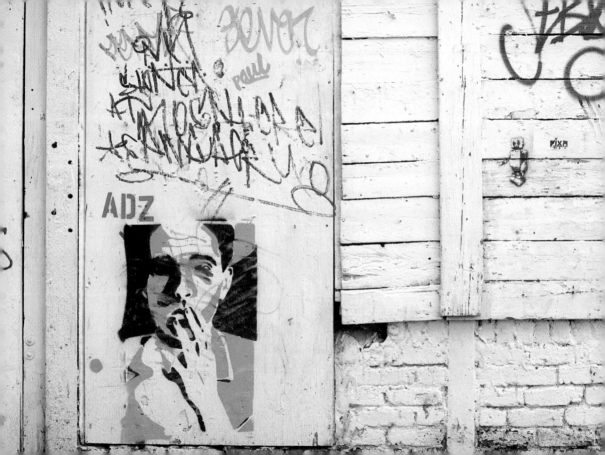

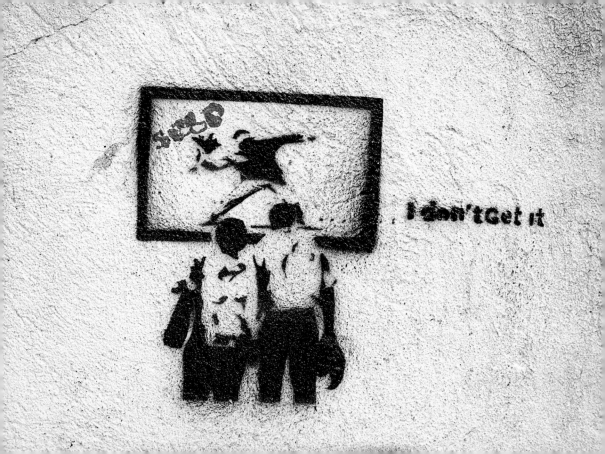

Prestel Publishing
900 Broadway, Suite 603
New York, N.Y. 10003
Tel. +1 (212) 995-2720
Fax +1 (212) 995-2733
www.prestel.com

Library of Congress Control Number:
2006928909

British Library Cataloguing-in-Publication Data: A catalogue
record for this book is available from the British Library.
The Deutsche Bibliothek holds a record of this publication
in the Deutsche Nationalbibliographie; detailed biblio-
graphical data can be found under: http://dnb.dde.de

Prestel books are available worldwide. Please contact your
nearest bookseller or one of the above addresses for
information concerning your local distributor.

Editorial direction: Philippa Hurd
Design, layout and typesetting: Mechthild Otto Gestaltung
Origination: Reproline Genceller

Printed in in Germany on acid-free paper

ISBN: 978-3-7913-3858-3

Prestel Verlag
Königinstrasse 9, D-80539 Munich
Tel. +49 (89) 38 17 09-0
Fax +49 (89) 38 17 09-35
www.prestel.de

Prestel Publishing Ltd.
4, Bloomsbury Place, London WC1A 2QA
Tel. +44 (020) 7323-5004
Fax +44 (020) 7636-8004

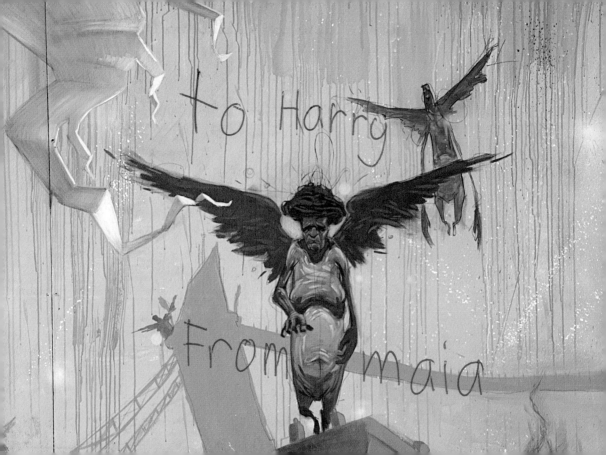